THE APERTURE HISTORY OF PHOTOGRAPHY SERIES

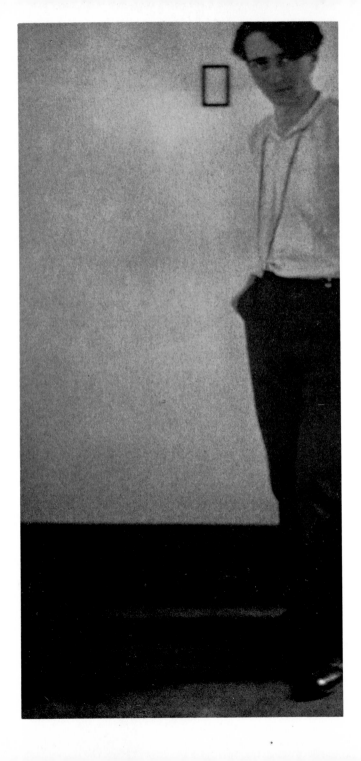

Edward Steichen

APERTURE

The History of Photography Series is produced by Aperture, Inc., under the artistic direction of Robert Delpire. *Edward Steichen* is the ninth book in the Series.

Aperture, Inc., publishes a periodical, portfolios and books to communicate with serious photographers and creative people everywhere. A complete catalogue will be mailed upon request. Address: Elm Street, Millerton, New York 12546.

Library of Congress Catalogue Card No. 77-70071

ISBN 0-89381-006-1

Manufactured in the United States of America.

The nineteen-year-old peering from the photograph has an engaging look. His smile is hesitant, he poses tentatively, half in, half out of the picture. But there is nothing tentative about the print itself, a beautifully pared-down exercise: a tiny rectangular frame on the wall in the background repeats the perimeter of the photograph; a lovely tension rides in the young man's off-center pose. It is 1898, and a very young Edward Steichen is not above trying out a little Whistlerian composition now that he feels he has a firm grasp of the medium he set out to learn a scant five years before.

The tentative pose in that early self-portrait may have been Steichen's last show of uncertainty in a career that spanned three-quarters of a century—over half the life of his medium—and that took in two radically differing photographic styles. We remember Steichen today for the gallery of glittering celebrities he recorded in the pages of *Vogue* and *Vanity Fair,* for his work as director of photography at The Museum of Modern Art, for *The Family of Man.* His cool, selective eye, his sense of design, his fascination with technique, coupled with a life-long romanticism and a manner described by at least one colleague as "majestically confident," swept him ahead of his contemporaries. He was so much a man of the mid-twentieth century that it is an effort to connect him with the gentle-looking boy in the nineteenth-century print.

Photography in the late 1890's was only a step away from Daguerre. Photographers who weren't busy composing moral montages and sentimental allegories were, for the most part, engaged in recording Mother, Dad, and the kiddies at fifty cents a shot for mantelpiece immortality. The happy few who regarded themselves as artists still saw the medium as a direct competitor of painting. Nearly every photographer worthy of a view camera joggled his tripod for a muted blur, bathed his lens in water or glycerin to produce a misty glow, and manipulated his prints and negatives for a "painterly" effect.

Steichen was no exception. By his cellar darkroom safelight—a candle masked with orange paper—he printed soft-focus pictures of his family, himself, and other Milwaukee camera en-

thusiasts as well as intensely romantic views of woodlots enveloped in thick haze. The landscapes are suburban Milwaukee transformed: conventional arcadias spun from roadside mud puddles and a few trees by a remarkable combination of will, imagination, and technique. But the early portraits promised even more: despite their equally soft-focus finish, there was a directness and technical security hard to match either then or now. The clarity of an early self-portrait with his sister (cover) is almost shattering. Two pairs of blue eyes gaze out of the frame through a veil of white, projecting a fierce Midwestern naïveté that is enhanced by the slight overexposure of the plate, the graininess of the print. This is no serendipitous accident. The young man who took the picture knew very well the effect he wanted, and he got it.

Thanks to this "majestic confidence" and to a head-on approach to life, Steichen got most of the things he went after. Staked by his mother and sister to a trip to Europe in 1900, he sailed into prewar Paris, a tough-minded innocent abroad. After devoting exactly two weeks to the formal study of painting at one of the scores of schools that dotted the Left Bank—he had ostensibly made the trip to become a painter—he packed up his brushes. The work the teachers admired was "cold, lifeless, slick . . ." he later wrote. "I was not interested."

But he was interested in the life around him. Paris was still *la ville lumière,* a magnet for the great and would-be great of the arts. The young Midwesterner was fascinated by this feast of the famous, though rarely so awed that he couldn't ask for a sitting. His talent and determination, coupled with the honest flattery of boyish admiration, opened doors of salons and ateliers that might have been closed to a more timid man. He met the Steins, Picasso, Matisse. Lions of the arts sat for him. Rodin and his work were long-term subjects. His portraits were all dark background with quasi-Titian highlights, but there was a sure feeling for clean, uncluttered composition and a sense of the individual sitter that set them miles apart from most work of the day. Not only was Steichen fascinated by his sitters, he was interested in them, and he understood the difficulty of catching a whole personality in a single frame: ". . . A portrait must get beyond the almost universal self-consciousness that people have before a camera. If some moment of reality in the personality of the sitter did not happen, you had to provide it in order to produce a portrait that had an identity with the person. The essential thing was to awaken a genuine response." The response is visible in the portrait of a café singer, Yvette Guilbert (page 81)—all raffish, tilt-nosed charm—and in a brooding, gentle photograph of Alphonse Mucha posed before one of his flowery graphics.

As the famous came to know him, his own fame spread. He mounted exhibitions of his work in London and Paris. When his money ran out and he returned to America to set up as a portrait photographer, he showed in New York with Stieglitz and other charter members of the

Photo-Secession. Public response to photography was growing, and Steichen caught on. No longer did he knock on the doors of the rich and the well-known; they sought him out. Robber barons and actresses, politicians and society ladies, all flocked to his Fifth Avenue studio to pose for "a Steichen." Now he could afford a farm in France, a home in New York. Money and public admiration flowed in. A New York critic breathed, "One should not say that he recalls Rembrandt, but . . . that Rembrandt will, in time, remind us of Steichen."

Steichen himself would have been the first to dismiss this gushy rapture as nonsense, but before it came to hand-to-hand competition between the camera and the old masters his photographic work and life style changed radically. As half the world went to war, Steichen fled his French farm just a day ahead of the Germans' arrival and went home to America. Overage for the draft, he volunteered and was sent back to France to serve two years as a photographic reconnaissance officer with the American Expeditionary Forces. He learned two things in battle: the camera's capacity for utter clarity and "the monstrous horror of war. . . . I smelled the rotting carcasses of dead horses, saw the white faces of the first three American dead that I had seen. . . . I saw the dried blood around the bullet hole in a young soldier's head. And he was only one of hundreds of thousands. How could men and nations have been so stupid? What was life for if it had to end like this? What was the use of living?"

In this deeply depressed state he returned at the war's end to his farm in France and took up his desultory affair with painting. Within three years he burned every canvas he had ever painted and set out, mid-life, with a camera to master "that charlatan, light, and the innate cussedness of inanimate things." Over the next few months he took, in every conceivable variant of natural light, between one and two thousand photographs of a plain white cup and saucer set on a piece of black velvet. "Finger exercises," he called them. Possibly a form of occupational therapy for a man seeking new directions.

When the cup and saucer had given up all their secrets, he turned to fruit, stopping down and trying long—up to thirty-six-hour—exposures for a feeling of volume. Seeds, flowers, eggs, shells, butterflies, all passed before his icy lens. He dabbled in a personal surrealism that he called abstraction, then discarded it after producing a series of particularly striking if enigmatic images. It was sometime between 1919, when he was mustered out, and 1922 that he regained the equilibrium he had briefly lost.

Possessed of himself and in control of a new, hard-edge style, he sold the farm in France and went to New York to immerse himself in commercial photography. Condé Nast—a "well-heeled Midwestern snob," according to one Nast employee—hired him in 1923 to join his stable of modish photographers at *Vogue* and *Vanity Fair*. Steichen's fame as a portrait photographer did him no harm in the rarified atmosphere of class, chic,

and almost-old money that prevailed in the magazine's offices. Nor was Steichen a total novice at fashion work. He had photographed gowns for Poiret before the war, his then misty images jibing beautifully with the French designer's gentle, Directoire styles. But now he had a new fashion philosophy: "I felt that a woman, when she looked at a picture of a gown, should be able to form a very good idea of how that gown was put together and what it looked like." His pictures for *Vogue* reflect this direct approach. The models stare straight at the camera, elegant as icebergs and as clearly visible as the letters on a page. The style was cooler and simpler than that of his colleague Hoyningen-Huene. And he imposed no "look" on his subjects as did his immediate predecessor at *Vogue*, Gayne de Meyer. Said a friend to Nast: "Your Baron de Meyer made every woman look like a cutie, but Steichen makes every cutie look like a woman."

Steichen's spare methods were a splash of cold water on the advertising format of the day. Magazine ads in the 20's tended toward busy, merchandise-filled conglomerations of type, art, and chattery borders. Steichen, working for J. Walter Thompson, pressed the case for simpler style, less fuss, more photographs. "I stand out firmly and forever against the picture of the cute cat coming out of the cute sock," he said. He sought "gutty pictures with meat and potatoes in them." And potatoes he served up: Jergens Lotion got a pair of practical-looking hands—they belonged to Mrs. Stanley Resor, wife of JWT's

president—peeling spuds, something of a departure from the usual moonlight-and-roses aura imposed by his contemporaries. His work for the ad world of the 20's and 30's might not topple the design empire of today, but it was a tiny revolution in its time.

Despite his fashion and advertising innovations, his real métier was still portrait photography. Condé Nast, a canny man, knew this and sent him a troupe of celebrities to photograph for the pages of *Vanity Fair*. These were the glitter people, lights of the theater and films, the literary crowd. They attended Nast's shimmery Park Avenue parties, exchanged *mots* at the Algonquin round table, actually called themselves "the intelligentsia" and "the literati." They were glamorous, glossy, often silly, and perfect subjects for the now equally famous photographer.

Steichen, through it all, had retained a sizable dollop of the Midwestern boy, of the warm hero worship that thirty years earlier had lit up the portraits of Rodin, Shaw, Matisse. He still believed in his subjects' glamour and was willing to enhance it on their terms. From 1923 to 1938 he produced a series of progressively slicker portraits of that fast-moving bunch of Beautiful People known as café society. His depictions are a far cry from the harsh, stripped-down figures of Richard Avedon and do not even remotely present the sense of life caught between one breath and the next that threads through the work of Henri Cartier-Bresson or, more recently, Lee Friedlander and Garry Winogrand. His portraits were formal and

public, not private. He caught the outer skins of his sitters so well that reality nearly came to imitate art. The *image* of sophistication became the criterion for a certain kind of live sophistication, as seen in the photographs of Tallulah, the Lunts, Astaire, Chevalier. Occasionally something direct shines through: an unadorned Garbo pulls her tousled hair back to stare straight out of the frame; card-carrying wit Dorothy Parker releases an unexpectedly comfortable warmth; a young Gloria Swanson exudes an aura of vamp, a pale-eyed tiger moth in a lace cage; Dietrich arches backward in a hat, almost a caricature of the worldly.

Steichen reportedly pulled in a six-figure salary for his work for Nast and JWT, and certainly charged $1,000 a sitting for a private portrait. He disclaimed avarice: "I was very busy during that period [the 20's and 30's], doing industrial pictures which interested me a great deal, and at the same time many people were bothering me to do portraits of them. So, as a way of stalling them off, I said I would have to charge a thousand a picture. When that got around, more people came for portraits than ever before."

He was not invariably impressed by his high-paying sitters. An unidentified lady came to him complaining that no one had ever been able to do her justice. Steichen photographed her, showed her the proofs, but "she threw them down and said: 'It's always the same. Tell me why none of you can take a decent picture of me.' I picked up a mirror and handed it to her."

Steichen was a high-energy player, and his dominating personality, coupled with his now legendary success, brought friction with some old friends. Stieglitz regarded him as a sellout, let it be known that he thought Steichen a "tradesman," and added reproachfully: "I never photograph famous people. Just old wagon horses and poor devils." Steichen countered this kind of opinion with the claim that all his work was commercial art; as far as he was concerned, the renaissance masters were just admen working for lucrative accounts with the church and state. "I wanted to work with business like an engineer. I wanted to make photography pay." And it did pay. But it also palled. By the late 30's, Steichen was bored with his own slick job. The props in his fashion photographs became outrageous—grand pianos and horses vie for attention with the models. In 1938, two years after *Vanity Fair* merged with *Vogue,* he quit: "Fashion photography had become a routine."

This was effectively the end of his career as a professional photographer, though it did not end his work in photography. He volunteered for military duty in the Second World War and led a team of young naval photographers through the South Pacific. At the war's end The Museum of Modern Art in New York created the post of director of the Department of Photography for him. There he mounted scores of exhibitions and encouraged the work of literally hundreds of photographers.

The most famous of the exhibitions, *The Family of Man,* was praised by many as an awe-

some hymn to the unity of mankind, cursed by some as an equally awesome exercise in naïveté, oversimplification, and sentimentality. Whatever its value, *The Family of Man* caught the public imagination, coming as it did on the heels of the McCarthy purges during a slight thaw in the Cold War. Hundreds of thousands flocked to the show in New York and around the world, staring appreciatively back at their own images in the photographs Steichen had selected.

Steichen himself felt that the exhibition was a call to peace in troubled times. He had seen war himself and he hated it—so much that he really could not photograph it. His war pictures are too beautiful. Infrared darkens the sky and superstructure of the carrier *Lexington*, picks out a Greek chorus of sailors waiting on deck for the coming strike on a Japanese-held atoll. The image is a masterpiece of composition, but it lacks the sense of immediacy and hurt that cuts through the war photographs of David Douglas Duncan or Robert Capa.

Though Steichen was aware of the obscenity of war, he was too much a romantic, too much a designer, too much a technician to preserve on film all its bloody ugliness. The rotting fingers of a Japanese corpse buried in rubble are perfectly placed in a frame of film; there is no real sense of the unseen mouth stopped with dirt. Steichen's eye has moved us a step away, granting us a small reprieve from reality. We are permitted to forget that the real horror shows not in the bodies of the dead but in the eyes of the survivors.

This step backward characterizes almost all of Steichen's later work. It keeps him one breath away from genius. A master technician who could make the camera do his bidding, his heart rarely showed in his work. Despite his fame, the transplanted Midwestern boy lived within him all his working life; he admired his glamorous sitters, endowing them with a sheen some could hardly claim as native. Yet the gloss, the beauty of composition, the technical perfection could conceal as much as it revealed. The "moment of reality" he evoked in his subjects was often a brittle one. When it was not, when life broke through, the effect is that of a veil suddenly pulled away: Gertrude Lawrence barely stifling giggles behind a fan; Fanny Brice startling with a tragic look; Steichen's young second wife, Dana, triumphant above a red, red apple. As a record of time and a style, the portraits of the teens and those of the 20's and 30's are matchless. In the course of a lifetime the innocent ferocity of the young man who gazed at us in Milwaukee was all but lost to the glitter of his subjects and transformed by the remarkable mastery of his technique.

Ruth Kelton

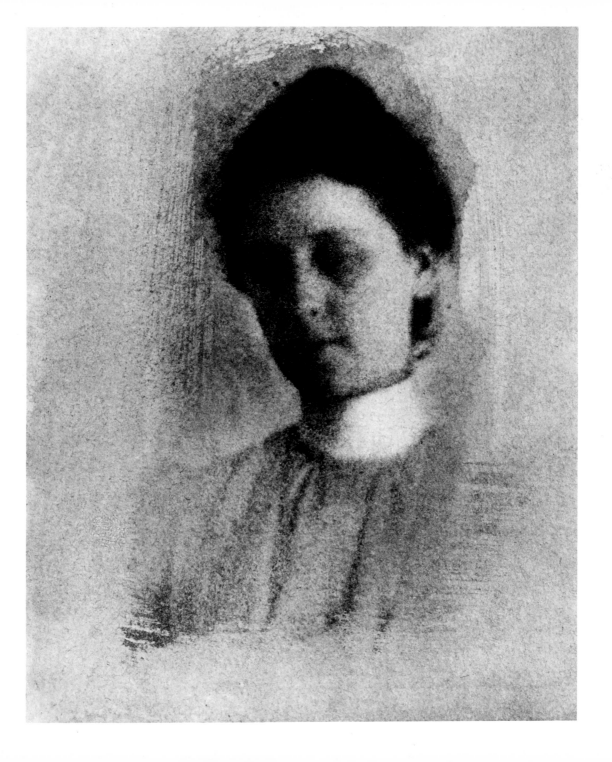

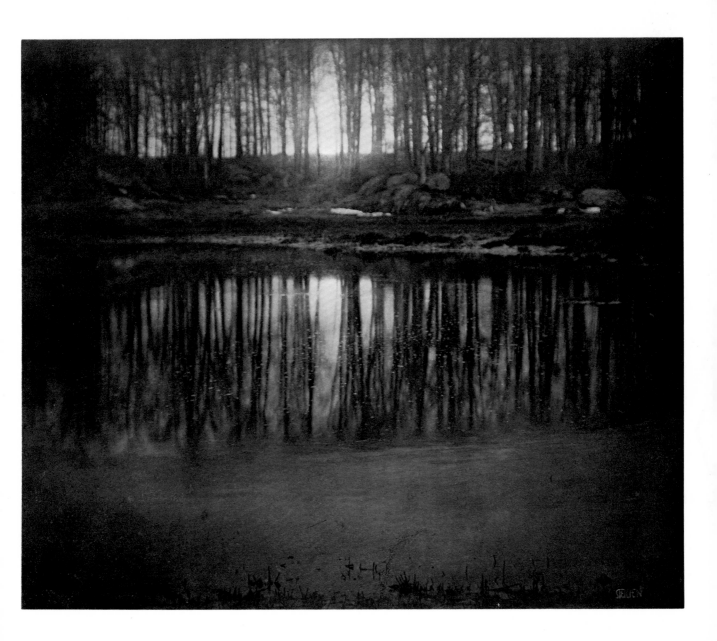

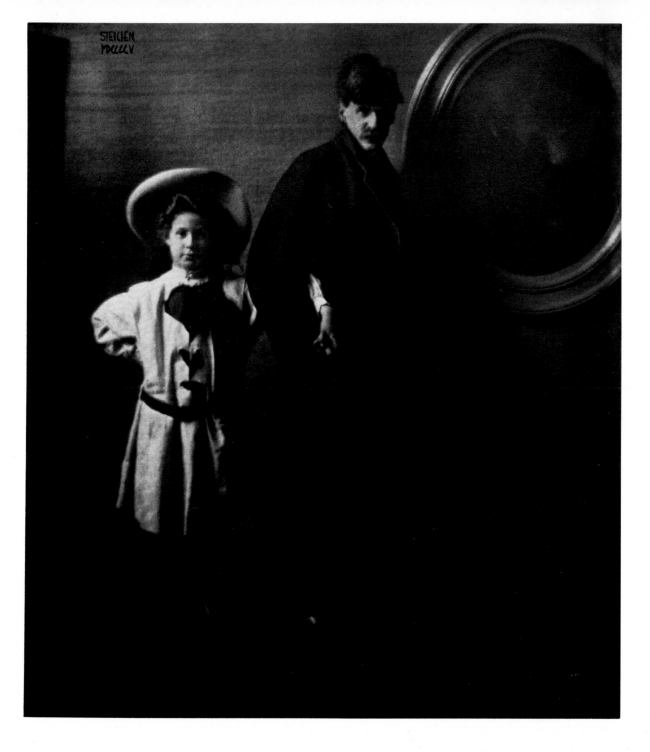

17

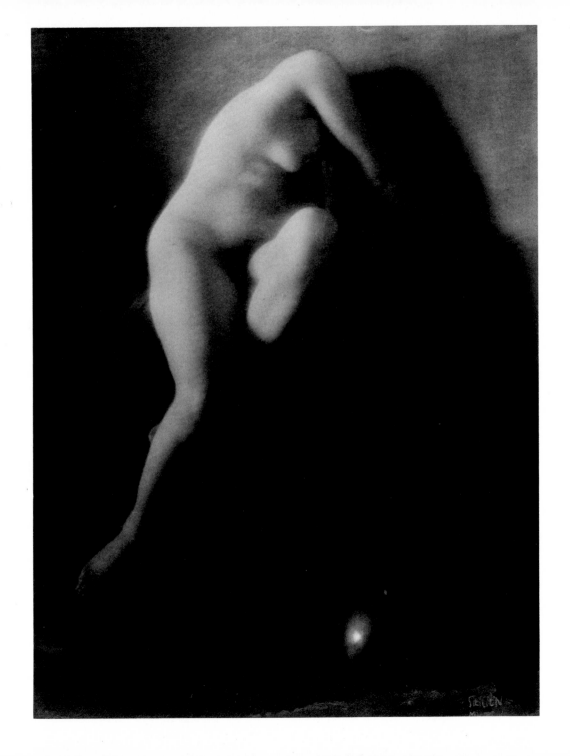

19

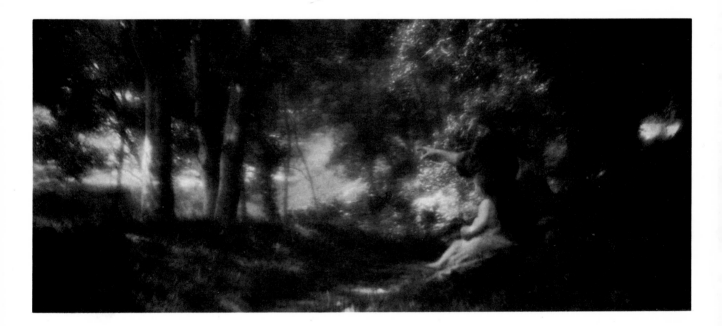

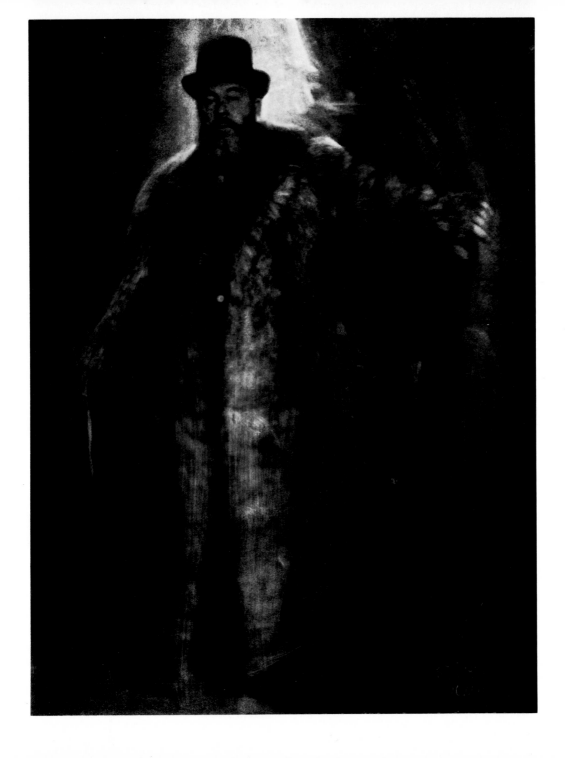

23

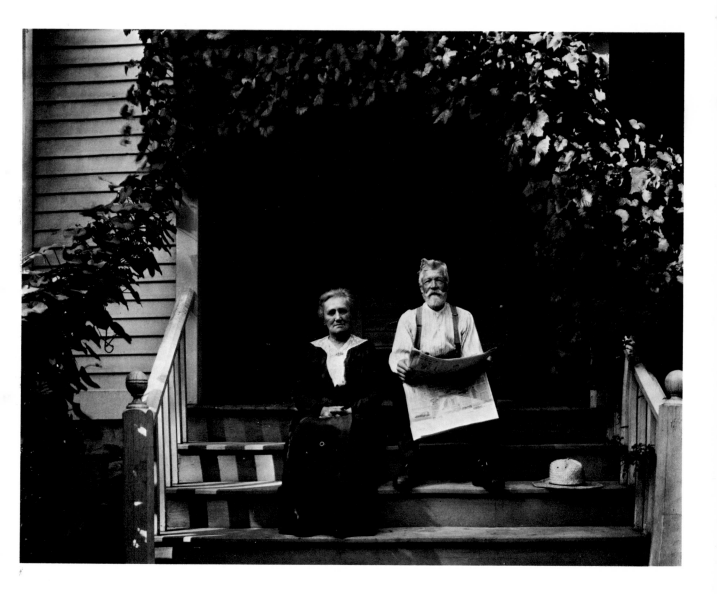

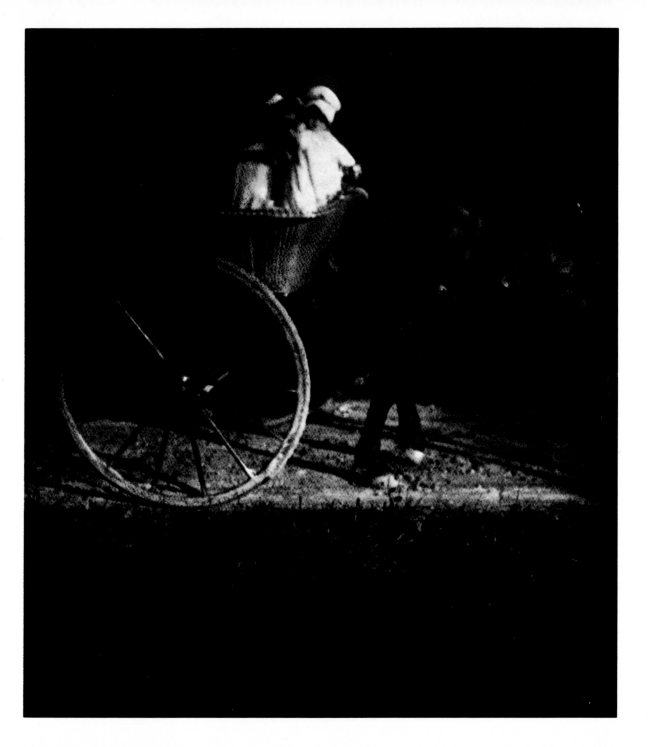

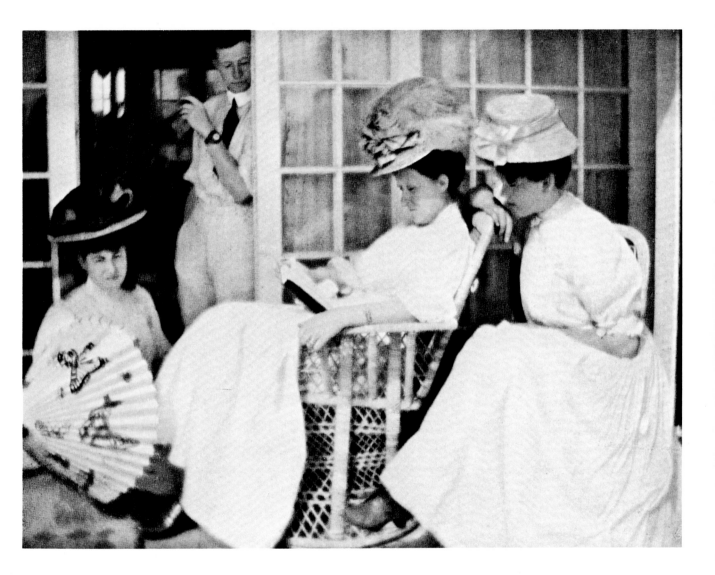

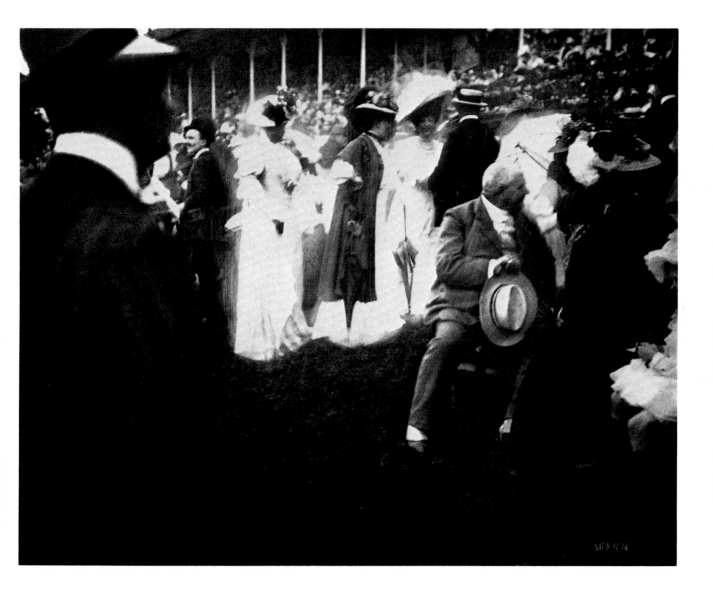

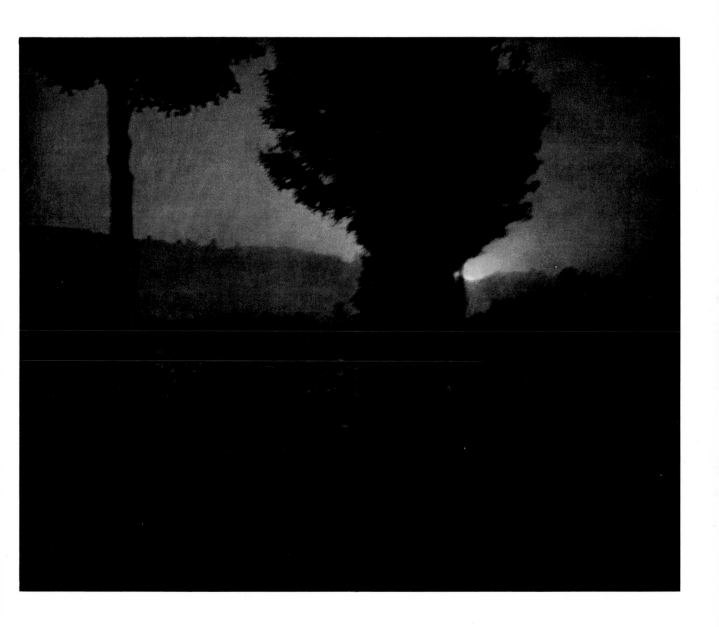

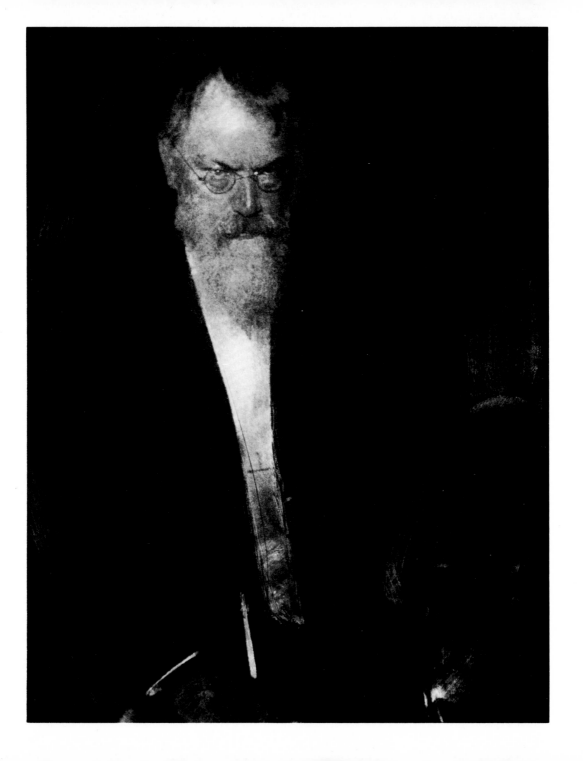

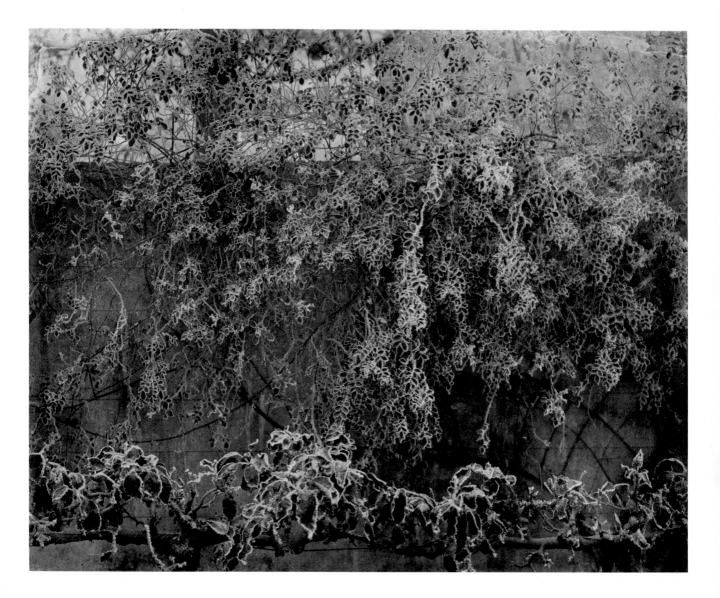

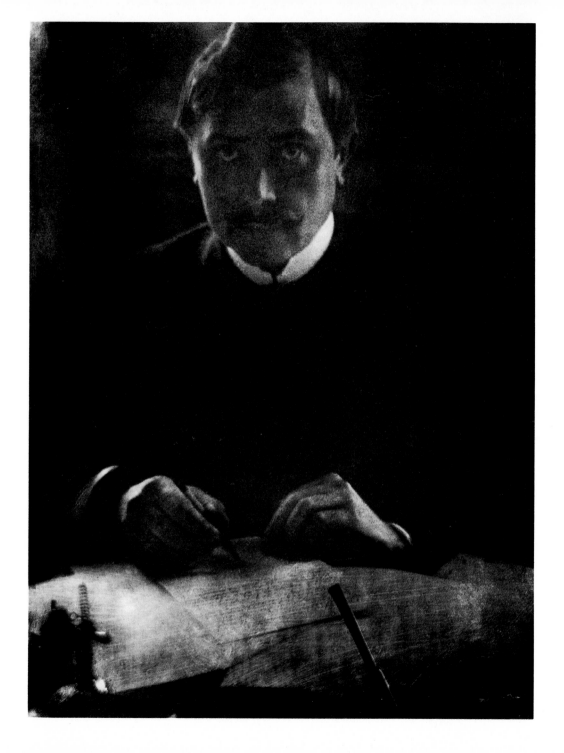

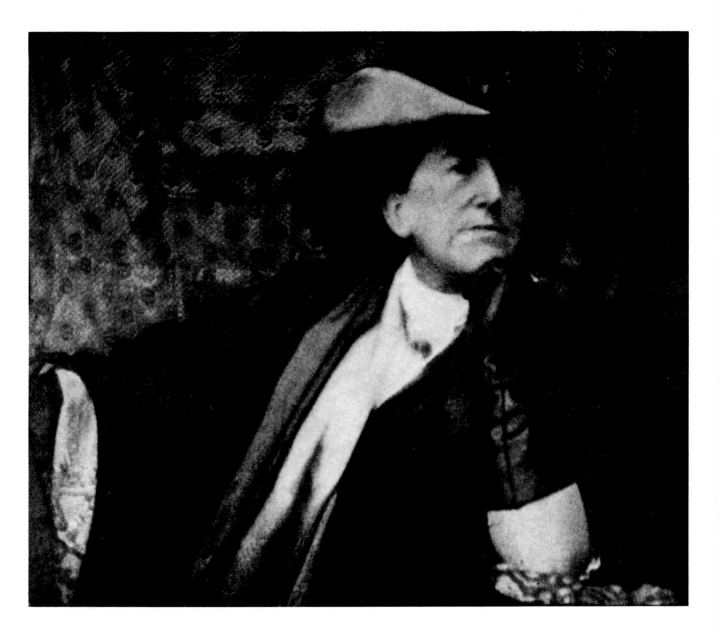

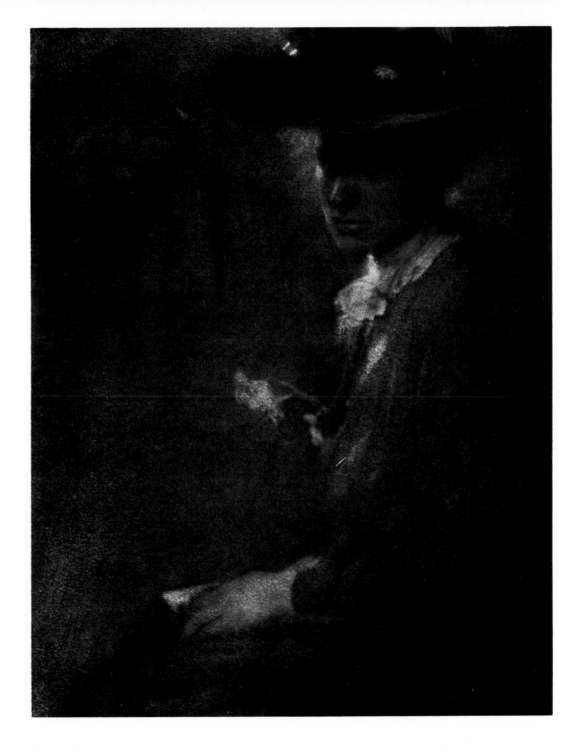

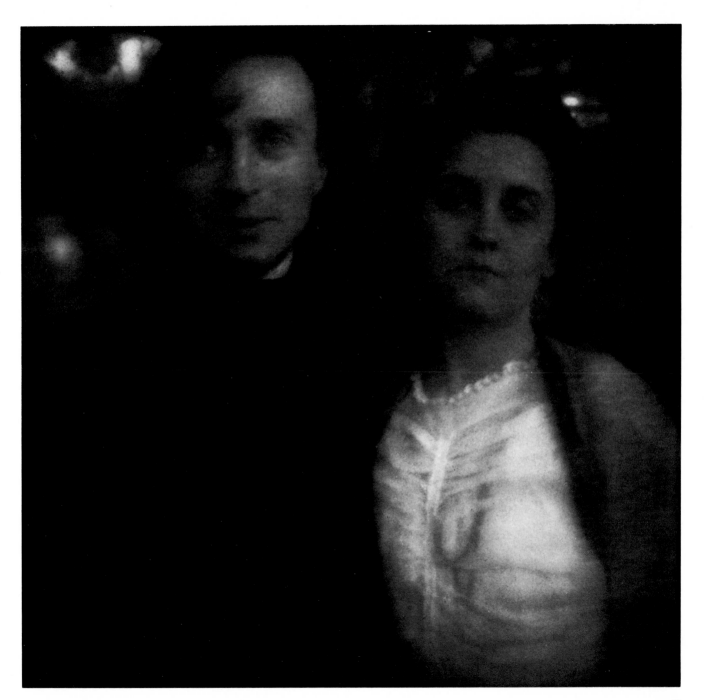

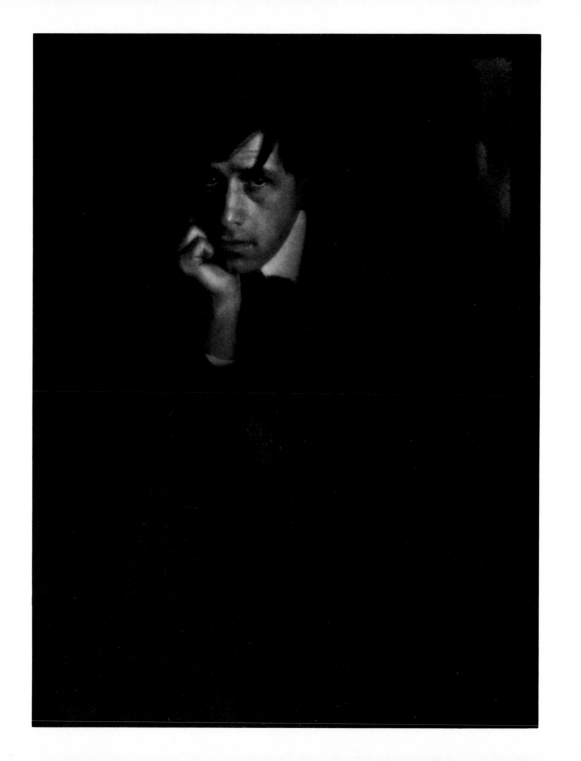

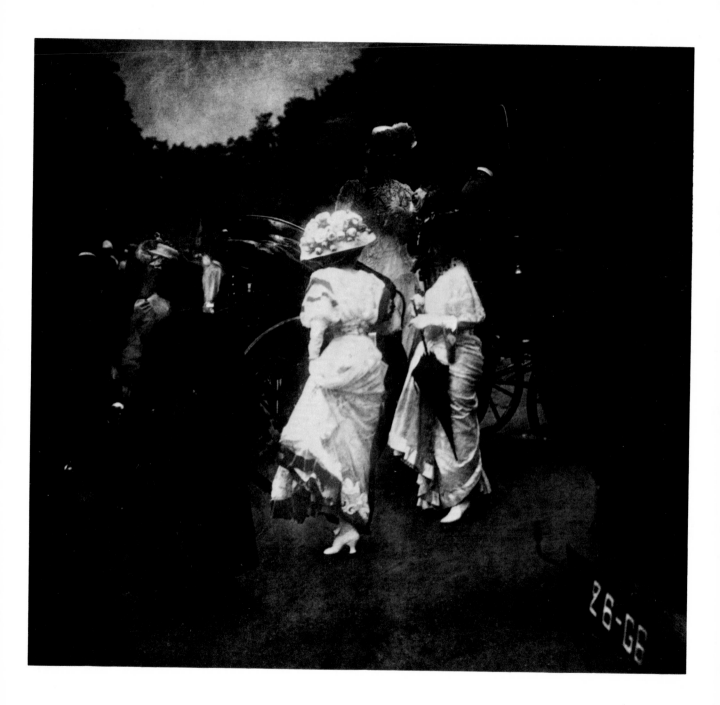

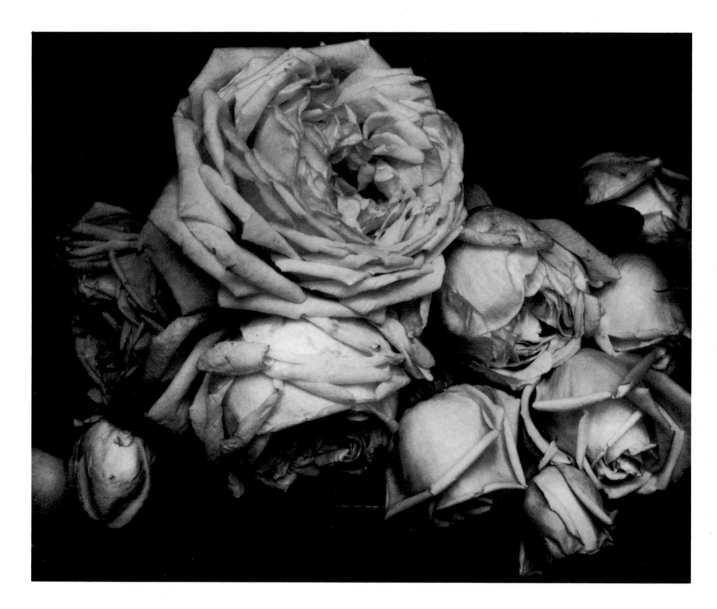

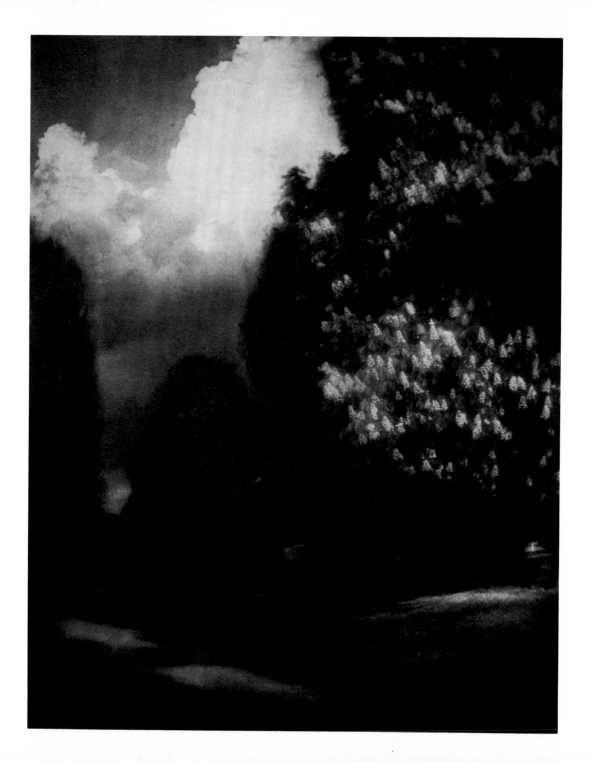

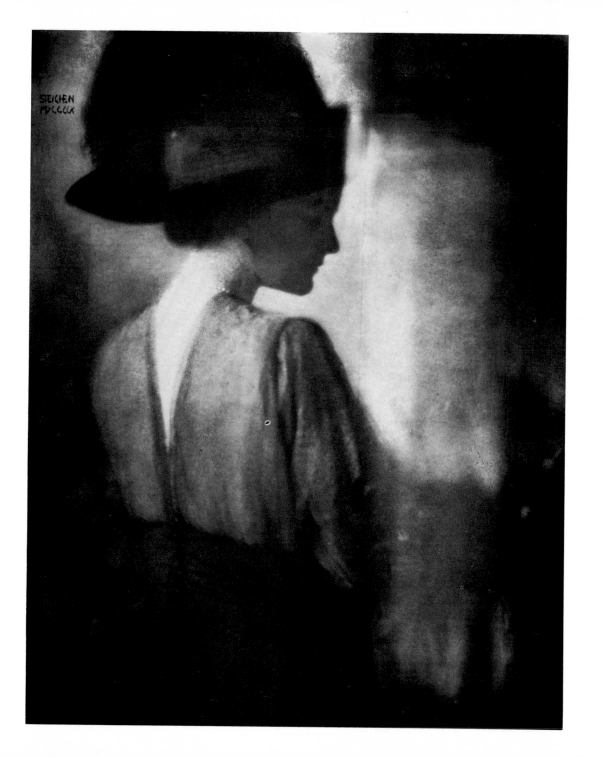

59

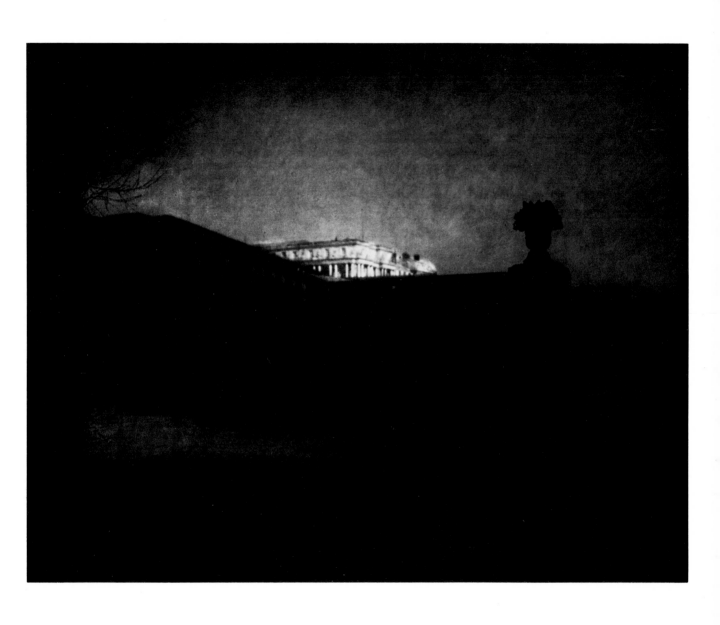

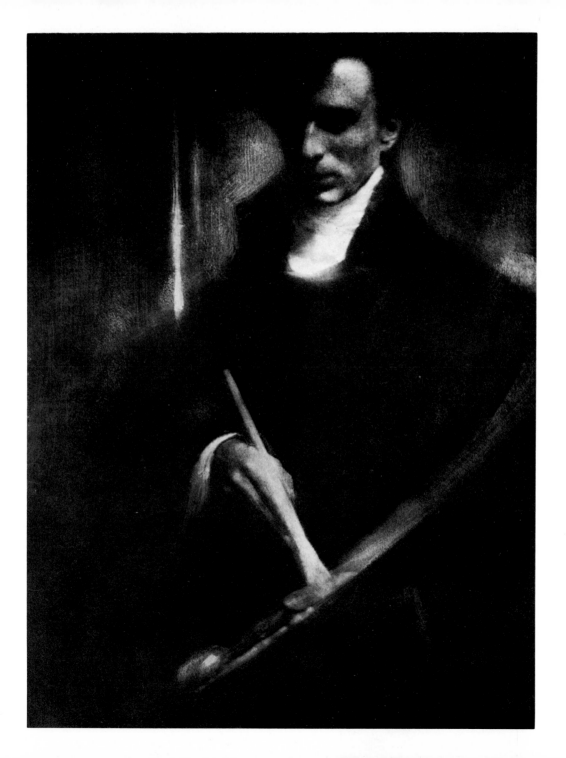

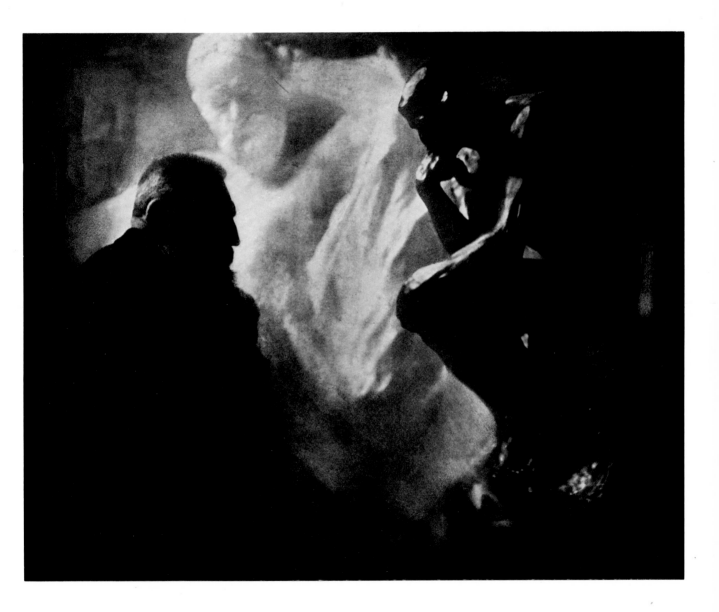

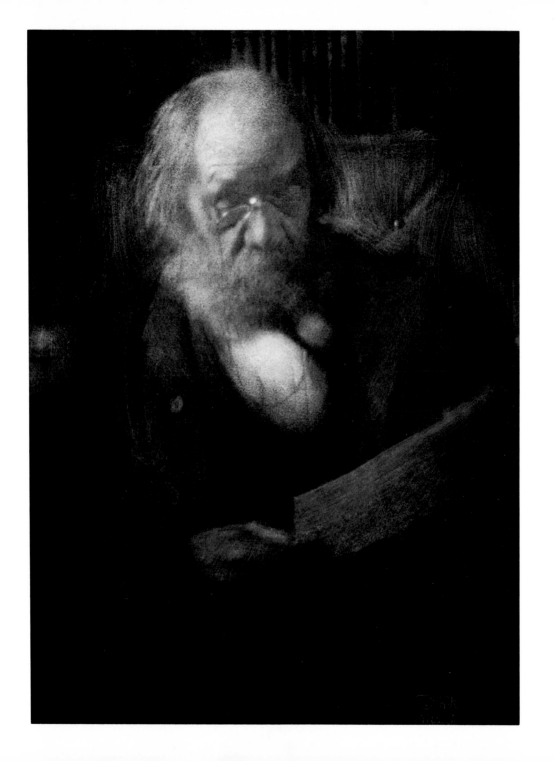

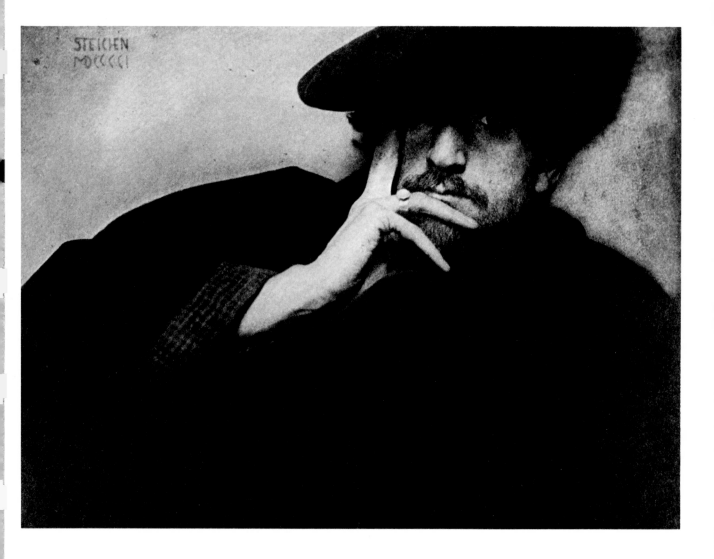

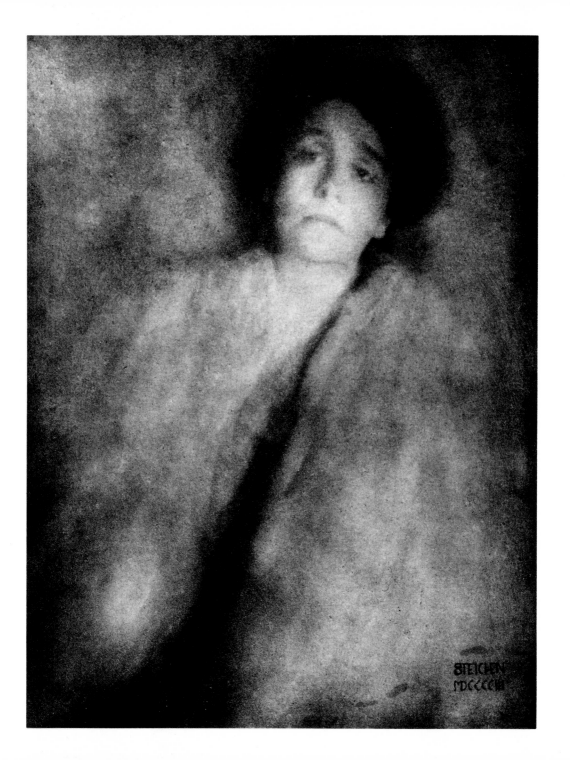

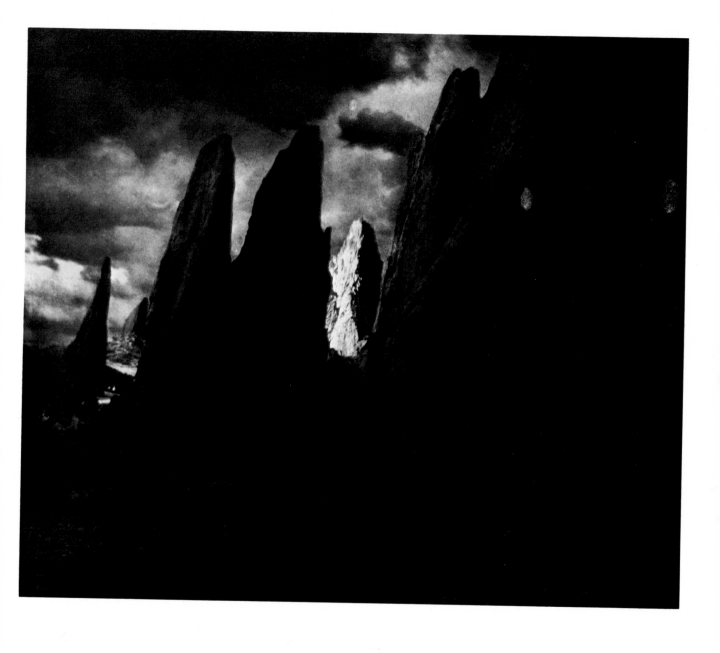

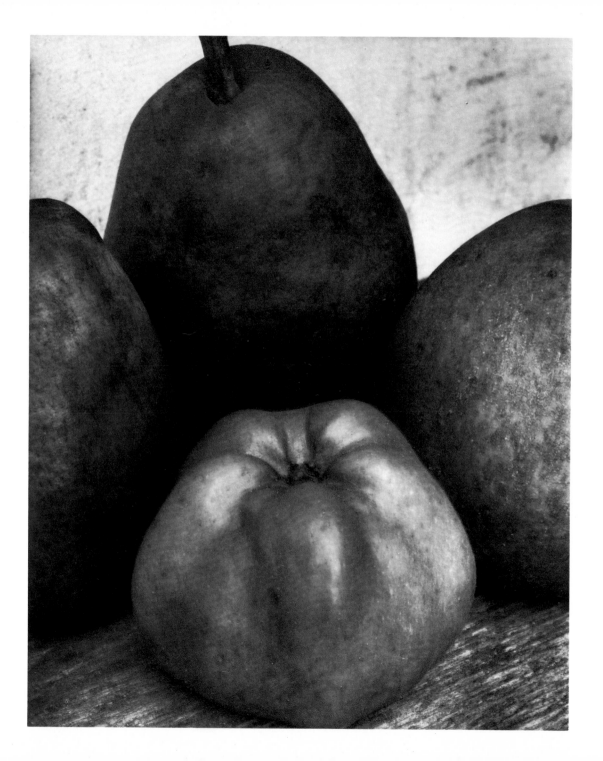

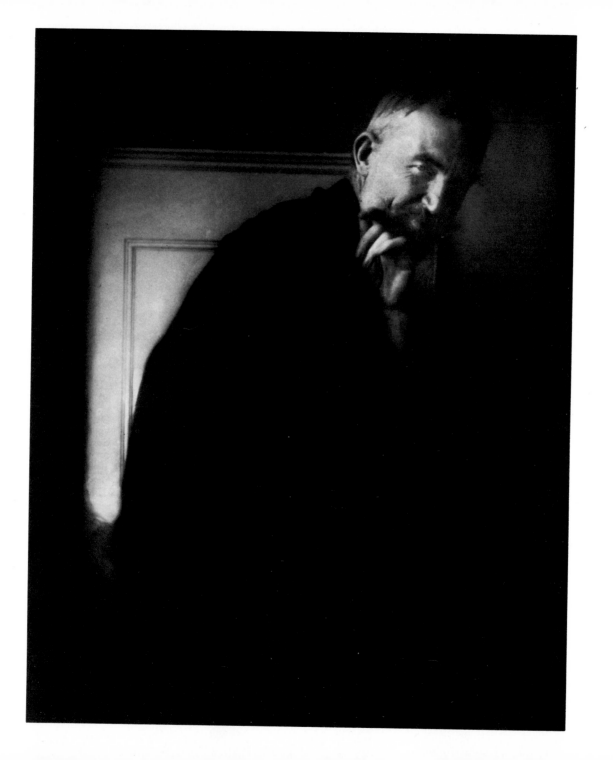

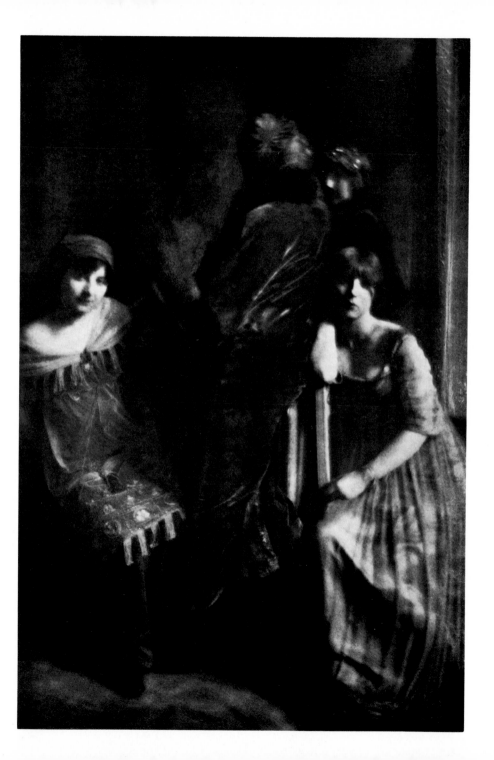

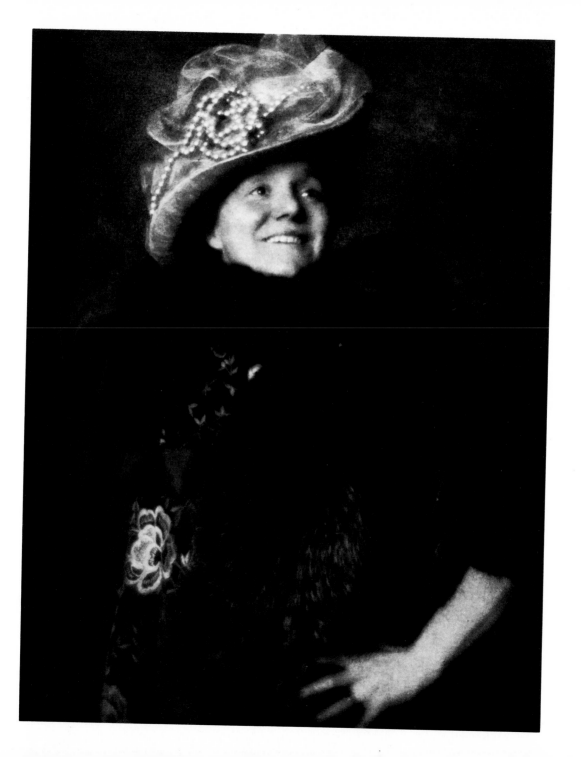

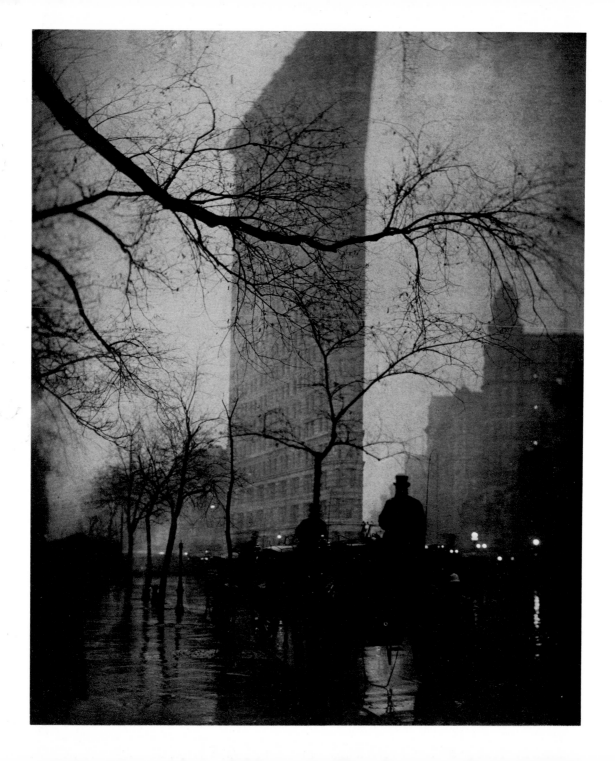

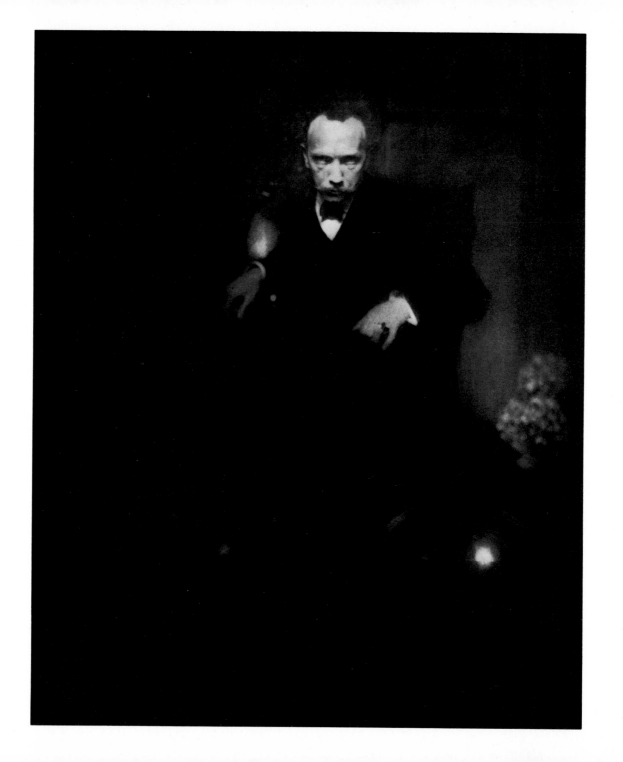

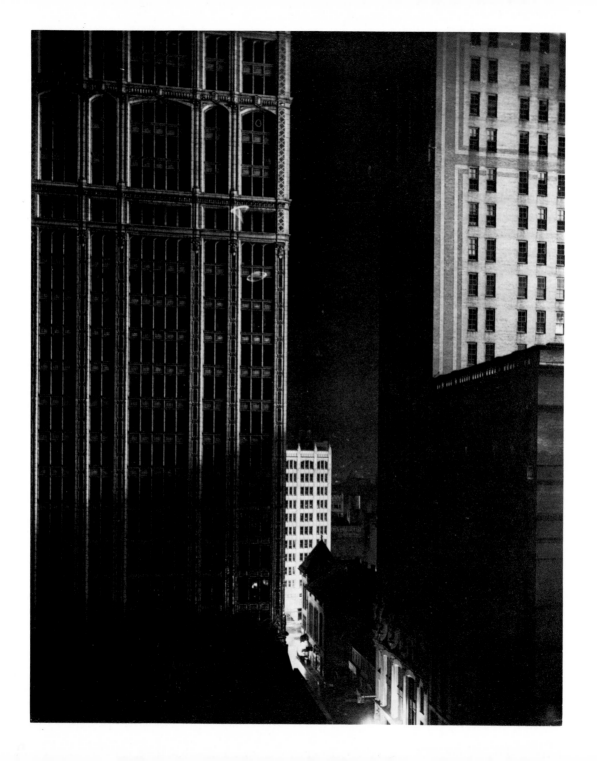

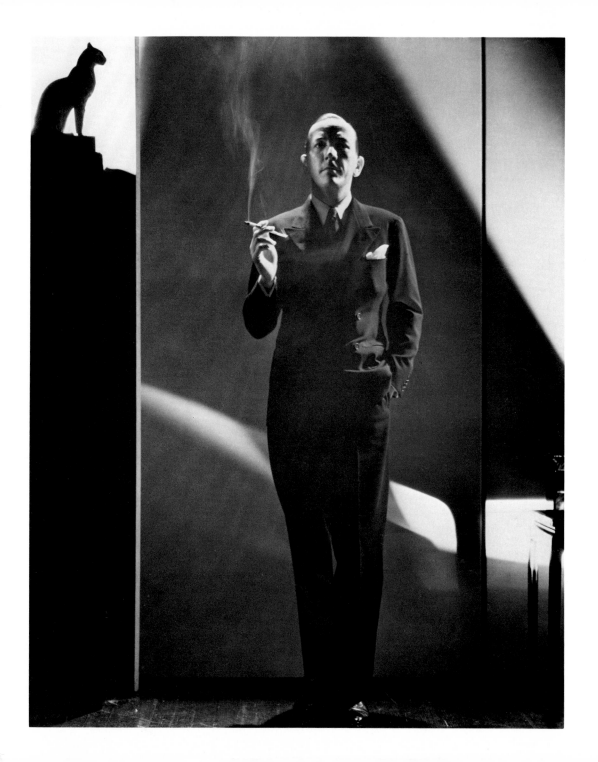

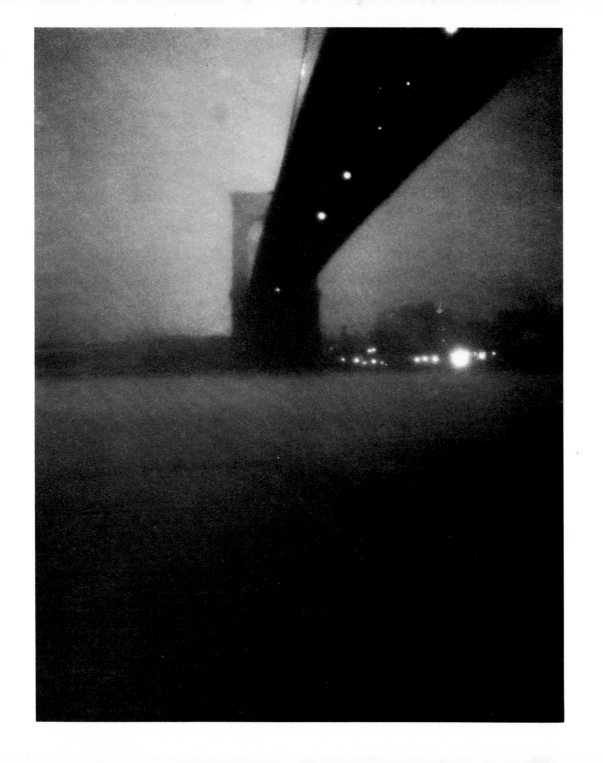

PHOTOGRAPHS

Front Cover: Self-Portrait with Sister, Milwaukee, 1900. The Museum of Modern Art, New York; Gift of the Photographer.

Frontispiece: Self-Portrait, Milwaukee, 1898. The Museum of Modern Art, New York; Gift of Sandro Mayer.

13. Polly Horter, Milwaukee, 1899. Collection of Joanna Steichen.

15. Moonrise, Mamaroneck, New York, 1904. The Museum of Modern Art, New York; Gift of the Photographer.

17. Alfred Stieglitz and Kitty, New York, 1905. Collection of Joanna Steichen.

19. In Memoriam, New York, 1904. Collection of André Jammes.

21. Untitled (Mary Steichen, Huntington, Long Island), 1905–06. The Museum of Modern Art, New York; Gift of Mary Steichen Calderone, M.D.

23. Albert Besnard, 1902. The Museum of Modern Art, New York; Gift of the Photographer.

25. Marie and Jean-Pierre Steichen, c1924. The Museum of Modern Art, New York; Gift of the Photographer.

27. Untitled (Mary Steichen in a cart), c1906. The Museum of Modern Art, New York; Gift of Mary Steichen Calderone, M.D.

29. Houseboat on the Thames, 1907 (lumière autochrome). The Museum of Modern Art, New York; Gift of the Photographer.

31. Steeplechase Day, Paris: Grandstand, 1905. Collection of Joanna Steichen.

33. Moonrise, New Milford, Connecticut, 1904. Collection of Joanna Steichen.

35. Franz von Lenbach, Munich, 1901 (from *Camera Work* gravure). The Museum of Modern Art, New York.

37. Frost on Rambler Roses, Voulangis, France, 1920.

39. Maurice Maeterlinck, Paris, 1901. The Museum of Modern Art, New York; Gift of the Photographer.

41. Gertrude Käsebier, c1907. The Museum of Modern Art, New York; Gift of Miss Mina Turner.

43. F. Holland Day, Paris, 1901. The Museum of Modern Art, New York; Gift of the Photographer.

45. My Mother, 1908. The Museum of Modern Art, New York; Gift of the Photographer.

47. Beatrix Baxter, 1901. The Museum of Modern Art, New York; Gift of the Photographer.

49. Untitled (Edward and Clara Steichen on Their Honeymoon), 1903. The Museum of Modern Art, New York; Gift of Mary Steichen Calderone, M.D.

51. Clarence H. White, 1903. The Museum of Modern Art, New York; on loan from Mr. and Mrs. Clarence H. White, Jr.

53. Steeplechase Day, Paris: After the Races, 1905. The Museum of Modern Art, New York; Gift of the Photographer.

55. Heavy Roses, Voulangis, France, 1914. The Museum of Modern Art, New York; Gift of the Photographer.

57. Horse Chestnut Blossoms, Long Island, 1904. The Museum of Modern Art, New York; Gift of the Photographer.

59. Agnes E. Meyer, New York, 1910. The Museum of Modern Art, New York; Gift of the Photographer.

61. Nocturne, Orangerie Staircase, Versailles, c1910. The Museum of Modern Art, New York; Gift, 1969.

63. Self-Portrait with Brush and Palette, Paris, 1901 (from *Camera Work* gravure). The Museum of Modern Art, New York.

65. Rodin, Le Penseur, Paris, 1902. The Museum of Modern Art; Gift of the Photographer.

67. Edward Everett Hale, Boston, 1903. The Museum of Modern Art, New York; Gift of the Photographer.

69. Solitude, F. Holland Day, Paris, 1901. Collection of Joanna Steichen.

71. Eleonora Duse, New York, 1903. The Museum of Modern Art, New York; Gift of the Photographer.

73. The Garden of the Gods, Colorado, 1906. Collection of Joanna Steichen.

75. Three Pears and an Apple, France, c 1921. The Museum of Modern Art, New York; Gift of the Photographer.

77. The Photographer's Best Model, George Bernard Shaw, London, 1907. The Museum of Modern Art, New York; Gift of the Photographer.

79. Poiret Fashions, Paris, 1911. The Museum of Modern Art, New York; Gift of the Photographer.

81. Vitality, Yvette Guilbert, Paris, 1901. The Museum of Modern Art, New York; Gift of the Photographer.

83. The Flatiron Building, Evening, New York, 1905. The Museum of Modern Art, New York; Gift of the Photographer.

85. Richard Strauss, New York, 1906. The Museum of Modern Art, New York; Gift of the Photographer.

87. Sunday Night on 40th Street, New York, 1925. The Museum of Modern Art, New York; Gift of the Photographer.

89. Noel Coward, New York, 1932. The Museum of Modern Art, New York; Gift of the Photographer.

91. Brooklyn Bridge, 1903. Collection of Joanna Steichen.

BRIEF CHRONOLOGY

1879. Born March 27 in Luxembourg.

1881–89. Family settles in Hancock, Michigan, where father works in copper mines and mother trims hats.

1889. Family moves to Milwaukee.

1894–98. Formal education ends at age fifteen. Begins four-year apprenticeship in a Milwaukee lithography company. Organizes and becomes first president of Milwaukee Art Students League.

1899. First public showing of photographs in Second Philadelphia Salon.

1900. Clarence White views Steichen photographs at Chicago Salon and lends encouragement; White writes about Steichen to Stieglitz, who buys three Steichen prints. Profound personal impression made by Rodin's work in Paris.

1901. Thirty-five Steichen prints included in "The New School of American Photography" exhibition which travels to Paris. Elected member of the Linked Ring, the photographic society of London.

1902. Becomes founder of the Photo-Secession and designs cover for *Camera Work*. First one-man show of paintings held at La Maison des Artistes, Paris. Returns to New York to open "291" Fifth Avenue studio.

1903. Marries Clara E. Smith.

1905. Collaborates with Alfred Stieglitz in organizing Photo-Secession Galleries in former "291" studio.

1904. Takes first color photographs.

1911. Urged by Lucien Vogel to make fashion photography a fine art. Begins to concentrate on painting.

1914. Returns from France to New York upon outbreak of World War I.

1917. Joins U.S. Army as volunteer and is commis-sioned first lieutenant. Receives various honors and awards during military career.

1919–22. Begins photographing objects to convey abstract meanings; experiments with abstract painting. Finally renounces painting in favor of photography.

1923. Marries Dana Desboro Glover. Becomes chief photographer for Condé Nast. Work appears regularly in *Vanity Fair* and *Vogue* (1923 to 1938). Begins advertising photography for J. Walter Thompson agency.

1932. Exhibits photomurals of George Washington Bridge in "Murals by American Painters and Photographers" at first showing of photographs by Museum of Modern Art, New York.

1935. Selects photographs for *U.S. Camera Annuals* (1935 to 1947).

1945. Named Director, U.S. Naval Photographic Institute.

1946. Released from active duty in Navy, with rank of captain.

1947–62. Serves as Director, Department of Photography, Museum of Modern Art. Relinquishes own photography.

1952. Begins preparation of "Family of Man" exhibition for Museum of Modern Art.

1955. Opening of "Family of Man" exhibition.

1960. Marries Joanna Taub.

1961. Exhibition "Steichen the Photographer" opens at Museum of Modern Art. Announcement is made of plans for Edward Steichen Photography Center in Museum of Modern Art.

1963. Awarded Presidential Medal of Freedom by President Kennedy.

1973. Dies March 25 at ninety-three.

SELECTED BIBLIOGRAPHY

BY EDWARD STEICHEN

1919. "American Aerial Photography at the Front," *The Camera*, 23 (July).

1941. "The Fighting Photo-Secession," *Vogue* (June 15).

1950. "The New Selective Lens," *Art News* (September).

1956. "The Living Joy of Pictures," *Holiday*, 19 (March).

1958. "Photography, Witness and Recorder of Humanity," *Wisconsin Magazine of History* (Spring).

1959. "My Life in Photography," *Saturday Review*, 42 (March 28).

1959. "My Half-Century of Delphinium Breeding," *The Delphinium Society's Year Book*, London.

1963. *A Life in Photography*. Garden City, N.Y.: Doubleday. Published in collaboration with The Museum of Modern Art.

ABOUT EDWARD STEICHEN

1897–1903. *Camera Notes*. Official Organ of the Camera Club. Edited by Alfred Stieglitz until 1902.

1901. *Photography as a Fine Art—The Achievements and Possibilities of Photographic Art in America*, Charles M. Caffin. New York: Doubleday.

1903–17. *Camera Work. A Photographic Quarterly*, 1–49/50.

1908. "The New Color Photography, *Century Magazine*, 75 (January).

1908. "Progress in Photography with Special Reference to Eduard J. Steichen," Charles H. Caffin. *Century Magazine*, 75 (February).

1922–38. *Vanity Fair*.

1929. *Steichen the Photographer*, Carl Sandburg. New York: Harcourt, Brace.

1932. "Edward Steichen, Photographer," Clare Booth Brokaw. *Vanity Fair*, 38, 4 (June).

1938. "Steichen," Margaret Case Harriman. *Vogue* (January).

1942. *Current Biography 1942*, Maxine Blosk (ed.). New York: Wilson.

1944. "Commander with a Camera," Matthew Josephson. *The New Yorker*, 20, 16 (June 3, 10).

1955. *Infinity* (January).

1956. *U.S. Camera 1956*, Tom Maloney (ed.). New York: U.S. Camera Publishing Corp.

1957. "Edward Steichen: Dissatisfied Genius," Lenore Cisney and John Reddy. *Saturday Review*, 40 (December 14).

1958. *Wisdom: Conversations with the Elder Wise Men of Our Day*, James Nelson (ed.). New York: Norton.

1959. "'De Lawd' of Modern Photography," Gilbert Millstein. *New York Times Magazine* (March 22).

1960. *Photo-Secession—Photography as a Fine Art*, Robert Doty. Rochester, N.Y.: George Eastman House.

1961. *Steichen the Photographer*. New York: The Museum of Modern Art. Distributed by Doubleday, Garden City, N.Y.

1970. "Happy Birthday, Mr. Steichen," Margaret Weiss. *Saturday Review* (March 28).

1977. *Alfred Stieglitz and the American Avant-Garde*, William Innes Homer. Boston: New York Graphic Society.

EXHIBITIONS

1899. Second Philadelphia Salon, October 21.

1900. Chicago Salon, April 3. London Photographic Salon, September 21. "New School of American Photography," Royal Photographic Society, London, October 10. Third Philadelphia Salon, October 22.

1902. "American Pictorial Photography," National Arts Club, New York, March 22. "One-Man Show of Paintings and Photographs," La Maison des Artistes, Paris, June 3.

1905. "Opening Exhibition," Photo-Secession Galleries, New York, November 24.

1906. Photo-Secession Galleries, New York, March 16. "Exhibition of Photographs Arranged by Photo-Secession," Pennsylvania Academy of Fine Arts, Philadelphia, April 30.

1908. "One-Man Show, Photographs in Monochrome and Color," Photo-Secession Galleries, New York, March 12.

1909. "International Group" (30 pictures), Dresden Exhibition, May.

1910. "The Younger American Painters," Photo-Secession, New York, March 21. "International Exhibit of Pictorial Photography," Albright Art Gallery, Buffalo, New York, November 4.

1915. "Paintings by Edward Steichen," M. Knoedler & Co., New York, January 25.

1932. "Murals by American Painters and Photographers," Museum of Modern Art, New York, 1932.

1938. "One-Man Retrospective Exhibition" (150 prints), Baltimore Museum of Art, Baltimore, June 1.

1950. "Retrospective," American Institute of Architects Headquarters, Washington, D.C., May.

1961. "Steichen the Photographer," Museum of Modern Art, New York, March 27.

HONORS CONFERRED UPON EDWARD STEICHEN

First Prize, Eastman Kodak Competition, 1903. Chevalier Legion of Honour, France, 1919. Honorary Fellow, Royal Photographic Society of Great Britain, 1931. Silver Medal Award (Annual Advertising Awards) "In Recognition of Distinguished Service to Advertising," 1937. U.S. Camera Achievement Award for "Most Outstanding Contribution to Photography by an Individual," 1949. "Front Page Award," Newspaper Guild, for "Family of Man" exhibition; other awards from A.S.M.P., National Urban League, 1955. German Prize for Cultural Achievement, Photographic Society of Germany, 1960. Silver Progress Medal, 1960. Premier Award of Royal Photographic Society of Great Britain, 1961. First foreigner to receive award from Photographic Society of Japan, 1961. Placed on Honor Roll, A.S.M.P., 1962. Presidential Medal of Freedom, 1963.